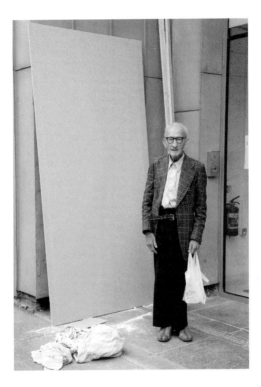

Photography by Martin Usborne.
Words by Joseph Markovitch, edited and compiled by Martin Usborne.
Design and layout by Martin Usborne and Friederike Huber.
Series design by breadcollective.co.uk

A CIP catalogue record for this book is available from the British Library.

US ISBN: 978-1-910566-17-6

First published in the United Kingdom in 2013 by Hoxton Mini Press.
Fifth edition printed 2016.

Printed and bound by Livonia Print, Latvia.

To order books, collector's editions and signed prints go to:

www.hoxtonminipress.com

WHAT I'VE LEARNED
IN 86½ YEARS

Words by Joseph Markovitch
Photographs by Martin Usborne

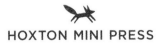

HOXTON MINI PRESS

Joseph Markovitch (left) with Martin Usborne

MAYBE READ THIS BIT FIRST

Martin Usborne

Summer 2007, midday. I looked out of the window of my East London photographic studio and there he was, shuffling slowly into Hoxton Square, plastic bag in hand, an oversized blazer slipping off his shoulders and chatting to various neon-clad youth lounging in the sun. He was so at odds with the crowd that I assumed he was lost or homeless or possibly a little mad. Surely that must be alcohol in his bag? I rushed downstairs, camera in hand, in the hope I might take his portrait and enter the image into a competition.

My preconceptions were wrong. It turned out that this old man, more than any of us young pretenders, was rooted in the area and was much more sane than all of us. For eighty years he had witnessed a continual cultural transformation that we could only imagine: where he knew cabinetmakers, we knew cocktail bars, where he frequented music halls, we walked past coffee shops. In his plastic bag he carried what he always carried – a small carton of orange squash. I took his portrait as he stood in the square. It was not a good shot. He was stiff, wooden almost, and he looked straight at the camera. It would never win me an award. His name was Joseph Markovitch.

That was the beginning. Over the next few months I bumped into him a few more times and he was kind enough to let me photograph him around the streets and in his home.

I planned to make a book about the history of the rich and diverse area around East London. But Joe wanted to talk about action movies, tall Scandinavian women, Nicolas Cage, the catarrh congesting his chest and how technology might blow up the world. He had never once left England but his vibrant imagination – aided by books and magazines from various Hackney libraries – had enabled him to travel through Amazonian rainforests and into the dark jungles of celebrities' private lives. He talked slowly but incessantly, almost without breath, and I began to record his words as well as his image.

The turning point in our friendship, and the moment this book was formed, came while I was photographing Joseph near my studio and a woman walked past me and shouted: 'You cunt! I bet he won't see any money from that will he?' I didn't know how to respond. Was the woman right? Was I taking these pictures for Joseph or for me? At that point my photography relaxed: I became less focused on getting the right shot and more focused on Joseph. The irony is that not only did I get better pictures but I found something very personal in the process. There is an element of my own loneliness in the photos of Joseph: I was single at the time and searching for a connection. A good photographic portrait always captures two people: the subject and the person taking the picture.

This book originated from a pamphlet that I made to accompany an exhibition about Joseph, that, to my surprise, sold out quickly. The following editions of the book – paperback, then thin hardback, then slightly less thin hardback, each

more involved than the last – created small profits that allowed Joseph to buy two phones, a DVD player, a new digital TV, a digital radio, two coats, a bundle of underpants, an array of winter socks, a new belt, and, crucially, a number of Clarks shoes for his long walks around East London. Joseph wasn't particularly bothered by the book or by the fact that people were buying it from as far away as Tokyo ('Yeh, the book's alright, Martin, it's alright, but did you know they opened a new coffee shop on Brick Lane?'), but he was excited by the new belt and particularly the phones. I was honoured to be allocated number 1 on his speed dials and to receive accidental calls from his pocket while I was abroad on faraway shoots. This is the fifth edition of the book and it contains a small number of extra quotes and images not seen before. Each time this book is printed I revisit my raw images of Joseph and transcripts of our lengthy conversations and find moments that I want to share.

The pleasure of making this book prompted the start of Hoxton Mini Press, a small publishing company which I now run with my wife (who, strangely enough, I met in Hoxton Square in the very same spot as Joseph but some years later).

Joseph and this book remain the inspiration behind much of what we do.

Thank you, Joseph.
With love, Martin Usborne.

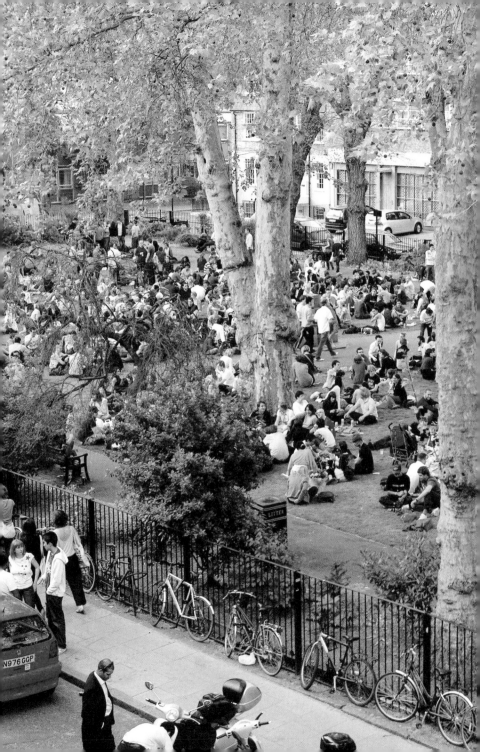

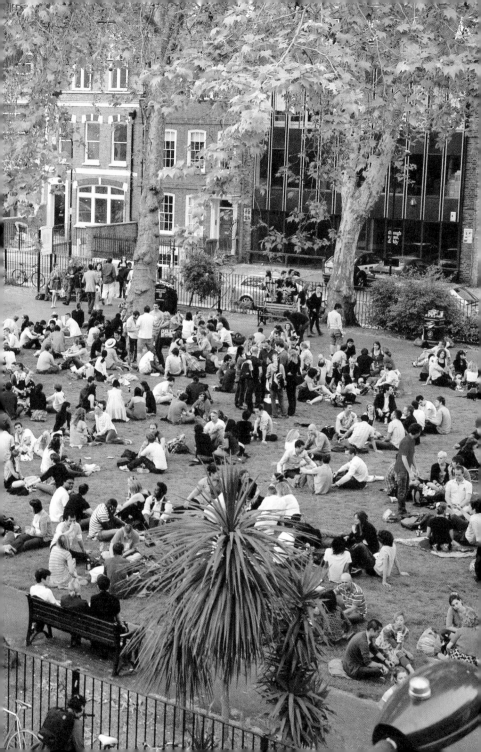

ON HOME

I've never left England. I would have liked to have seen islands and jungles and trees and animals and fish and elk and mountains. But I've lived in East London all my life and that's my home. I once went to the seaside with my mother. When I was young, everyone was a cockney. It was like looking at the same face all the time. Now it's all mixed up. I like it. Australians, Americans, Jewish, Blacks, Brazilians, Germans, it's all over the place.

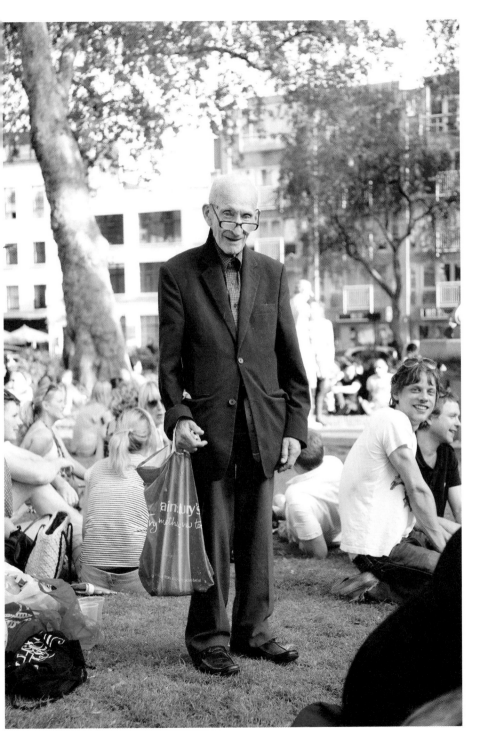

ON CHILDHOOD

I was born right by Old Street roundabout, in Hoxton, East London, on January 1st, 1927. Some of the kids used to beat me up – but in a friendly way. Hoxton was full of characters in those days. The Mayor was called Mr. Brooks and he was also a chimney sweep. Guess what? Before the Queen's Coronation, he was putting up decorations and he fell off a ladder and got killed. Well, it happens. Then there was a six-foot-tall girl, she was really massive. She used to attack people and put them in police vans. Maria was her name. Then there was Brotsky who used to kill chickens with a long stick. His son's name was Monty. That's not a common one is it? 'Monty Brotsky'.

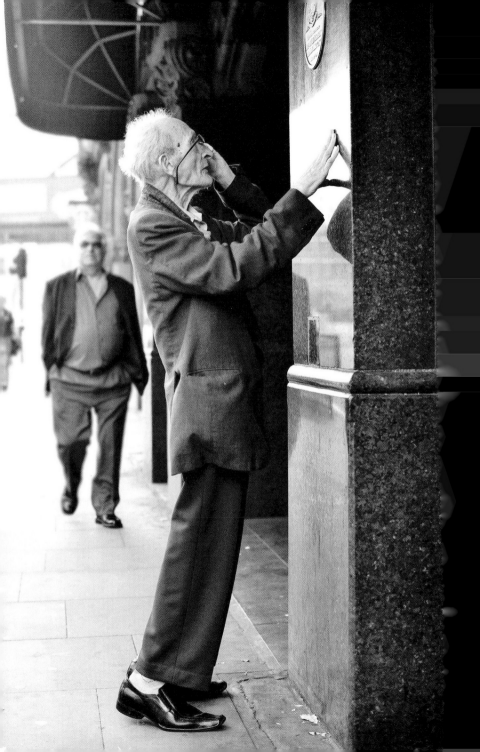

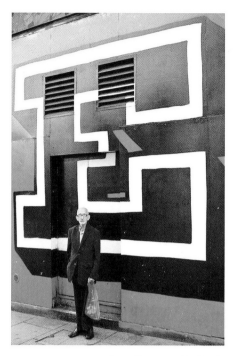
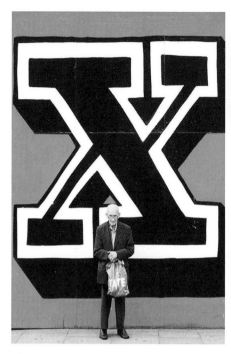

A lot of young kids do graffiti around Hoxton ...

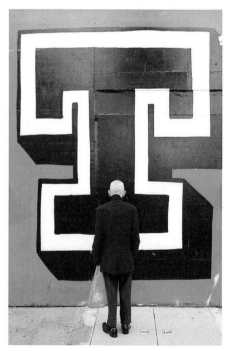
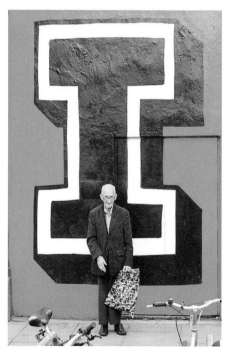

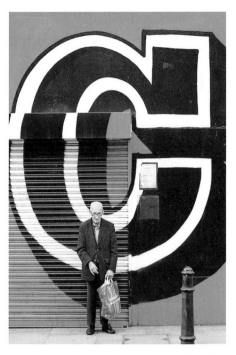
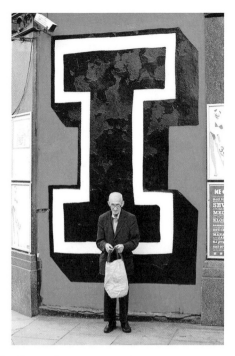

... it's nice. It adds a bit of colour, don't you think?

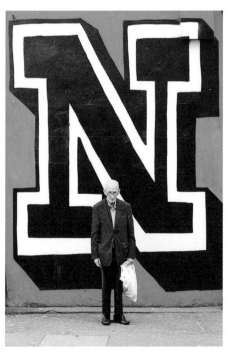
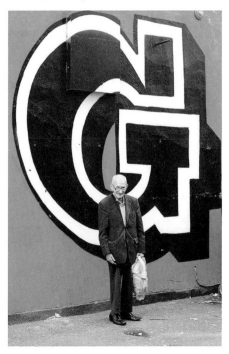

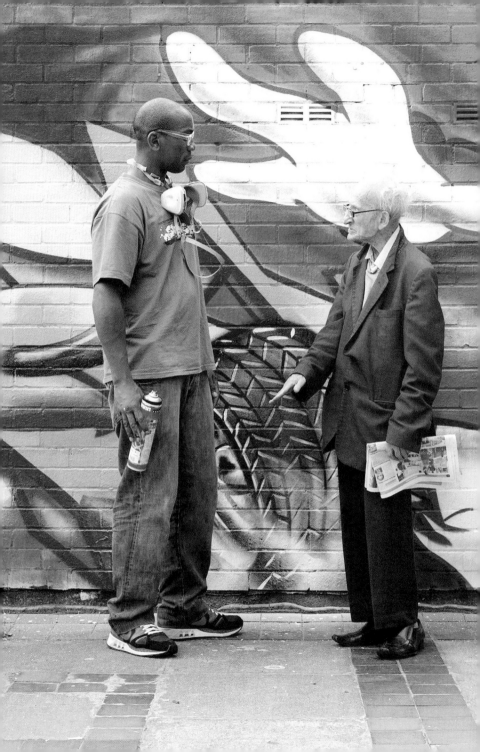

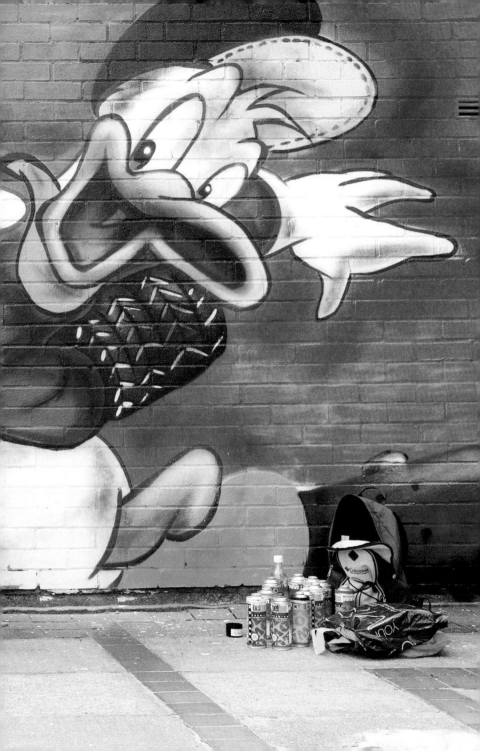

ON FASHION

In the old days, when a man went to see the opera he had on a bowler hat. If you were a man and you walked in the street without a hat on your head you were a lost soul. People don't wear hats any more... but they wear everything else, don't they?

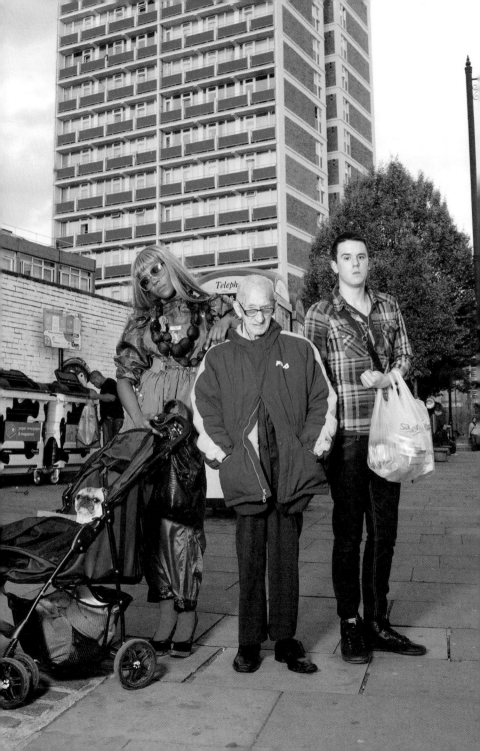

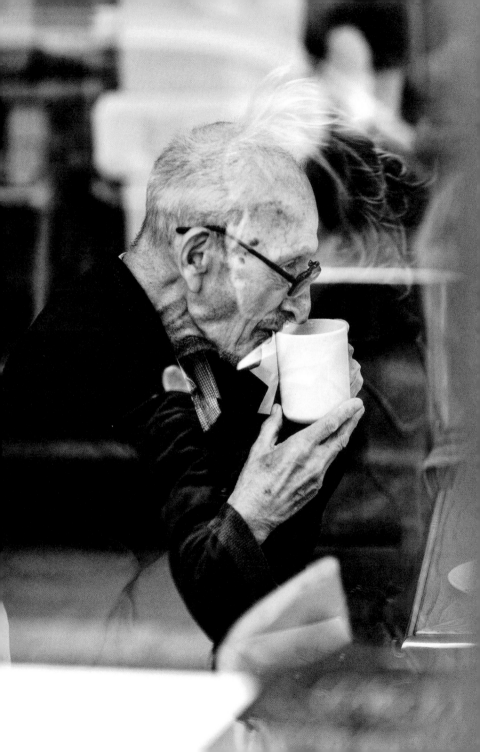

ON RELATIONSHIPS

I've never had a girlfriend. It's better that way. I've always had very bad catarrh so it wasn't possible. And I had to care for my mother. Anyway, if I was married I would have been domineered all my life by a girl and that ain't good for nobody's health. You know that Bernie Ecclestone, from Formula One? He is really, really small. He was married to a Serbian girl who was six-foot-one. I say 'lucky Bernie'. People always say that dark-haired girls like millionaires. My preference is very tall blonde Scandinavians. If they are Hispanic and really tall then I might just like them with dark hair. I would have liked to have had a girlfriend but it's OK. I've seen the horse and cart, I've seen the camera invented, I've seen the projector. I never starved, that's the main thing.

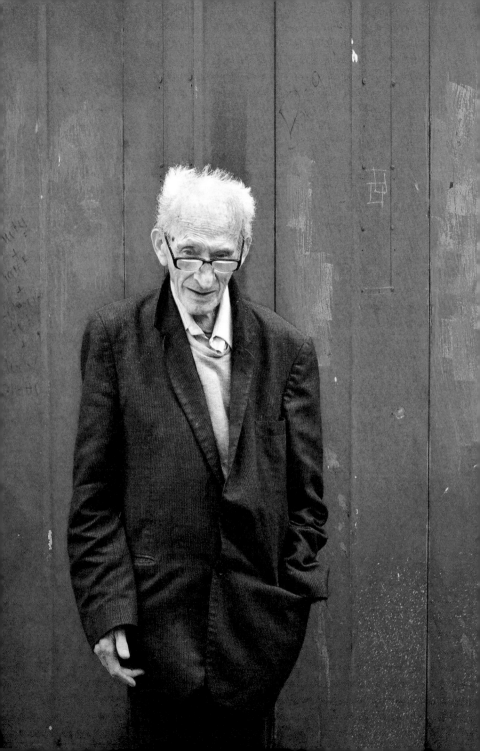

ON WORK

I worked two years as a cabinetmaker in Hemsworth Street just off Hoxton market. But when my sinuses got bad I went to Hackney Road putting rivets on luggage cases. For about twenty years I did that job. My foreman was a bastard. Apart from that it was OK. But if I was clever, very clever, then I would have liked to be an accountant. It's a very good job. And if I was less heavy... you know what I'd like to be? I'd like to be a ballet dancer. That would be my dream.

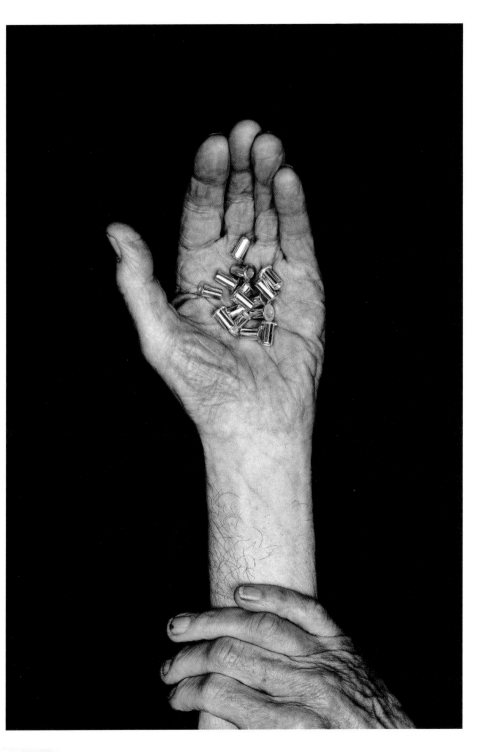

ON ART

I find all this modern art very strange. I'm not used to things I don't understand, things what ain't paintings. I like the old paintings. I'm interested in Renaissance – you know what that is? Things what are ancient. Anything between one hundred and three hundred years old. I also like things that are produced by Picasso, people like that. Toulouse-Lautrec. He was not too bad, but he had an unhappy life. Hey, do you know that Tracey Emin? She lives around here. You know that she stopped a skyscraper being built in Hoxton Square. I'd like to meet her.

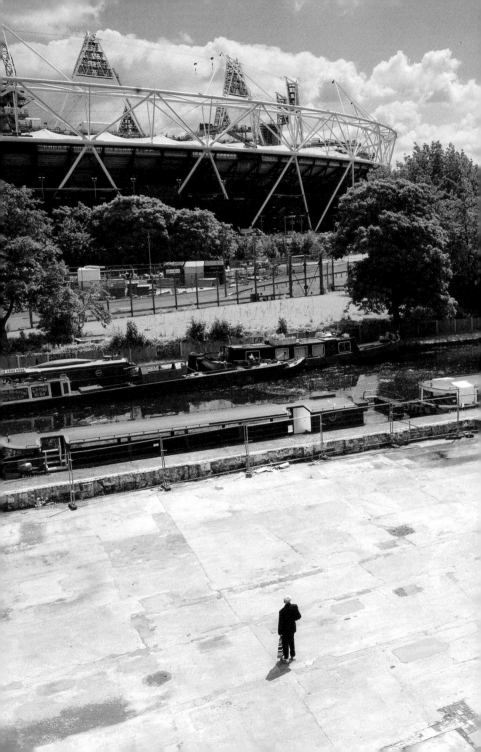

ON THE OLYMPICS

We used to have cabinetmakers and tailors and music halls. Now we have a big stadium. I'm not sure about it.

ON FAMILY

Me and my family used to go to Hampstead Heath to see the fair. We had ice cream. There was a parrot who used to swear at me. It was perfect. I remember falling into some stinging nettles. I also remember Queen Mary's Jubilee. We had parties in the street. I was opposite the London Hospital in Whitechapel, with my mum and dad, and Queen Mary and King George came past. What's all this about broken families these days? The most important thing is to stay together.

Joseph (bottom centre), Leah (left), Milly (top), Morris (right).

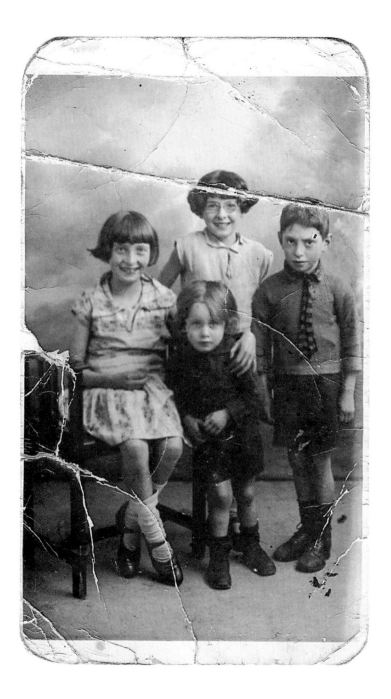

ON HIS MOTHER

My mother was a good cook. She made bread pudding. It was the best pudding you could have. She was called Janie and I lived with her until she died. I wasn't going to let her into a home. Your mother should be your best friend. I once had a locket with a photo in it of my mother. I had to move house a few times and it went missing. There's no photos of her anymore. This is the shape of her locket, it was almost round.

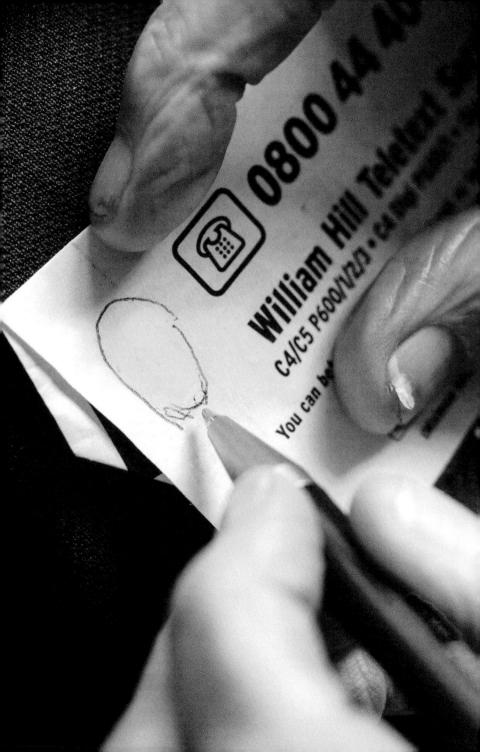

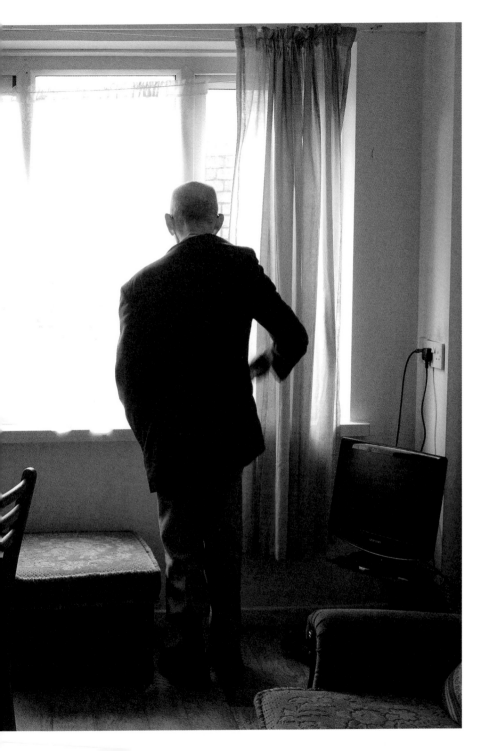

ON SADNESS

There's no point crying about things, is there? People don't see you when you're sad. Best just to keep walking.

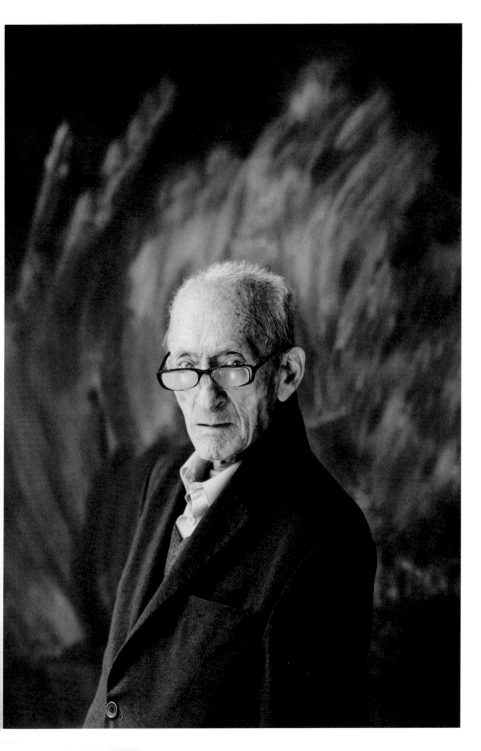

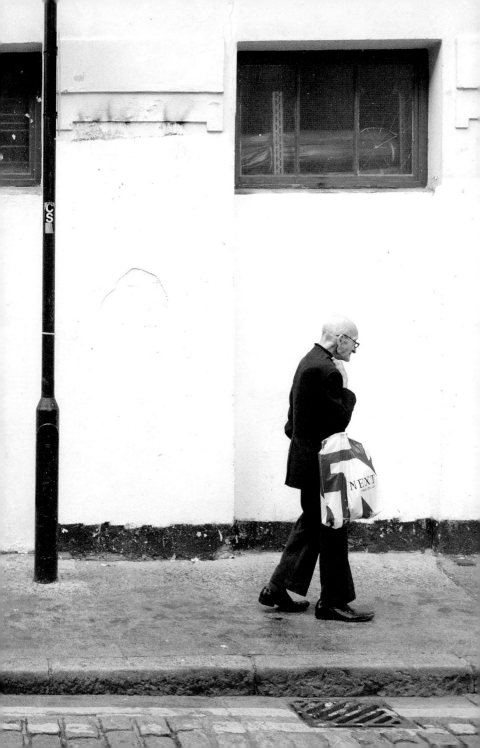

ON WALKING

I like to walk because I see things that I would never see, like boats and ships and strange people's faces. I would like to walk in the rainforest but I'd have to be careful of the snakes and the spiders – it's very dense over there. Did you know that somewhere in the rainforest there is a cure for all the bad diseases in the world but the governments don't want to spend. I'd probably live in a hut out there.

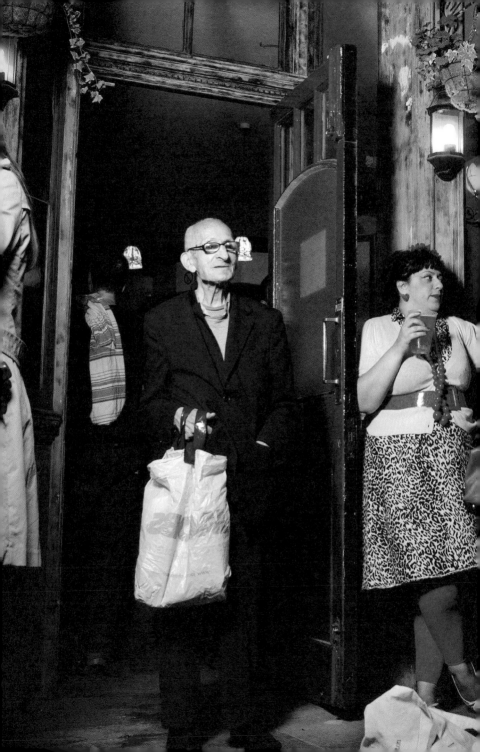

ON THE PAST

The best time to live in East London was in the Thirties. Although we was poor everyone helped each other. If your neighbour was ill you made them a plate of soup. Now someone might beat up your mother. We had a fish and chip shop opposite the bingo – it cost two pence for fish and chips, then we had that shop that sold pants and knickers. You had the tea company at the beginning of the Bethnal Green Road. You know Commercial Street? On the right hand side there was a policeman who was from Wales and he was called Taffy. Then there was Debbie Plotz, my friend, and her mother who was really fat, Habba Plotz.

ON MANNERS

The other day I saw a smart man on a bus. He jumped off but left his briefcase behind. I said 'oi' and I gave him the briefcase and he didn't say 'thank you'. I saved all that trouble for him. I don't want nothing from the man, but a 'thank you' would be polite. Money don't make you polite. What makes you polite is that if you are brought up poor, and then you get rich, then you are polite. Because the suffering makes it like that.

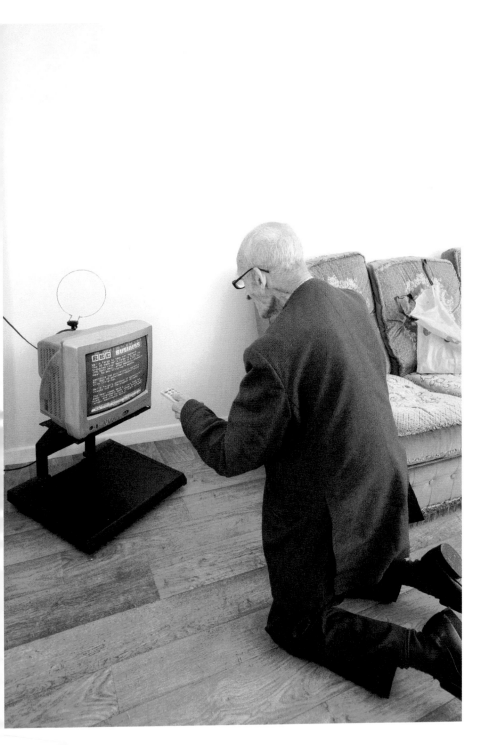

ON MONEY

I don't know what I would do if I won the lottery. There is that children's charity, what's it called? I wouldn't help them because they say the money goes straight to the terrorists. If I won a small amount of money I would give it to the Synagogue Burial Society – because I've got to pay for my own funeral. I've been paying into it for 35 years but every year they raise the prices. I could have buried a football team by now. I think I won't pay it any more. What's the worst that can happen? I die?

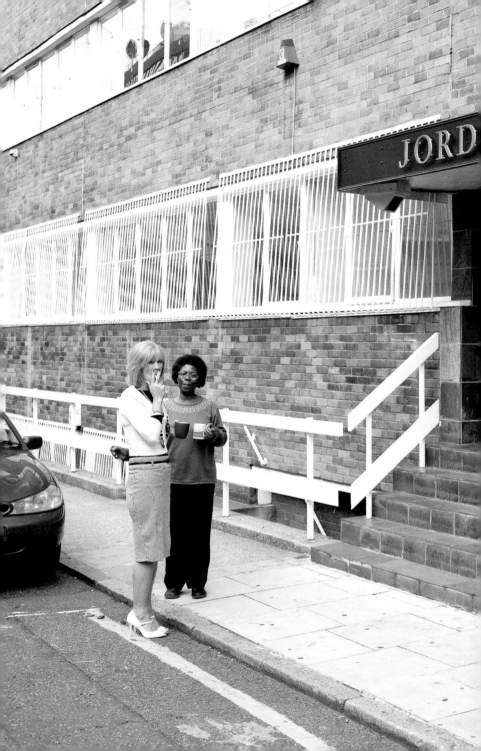

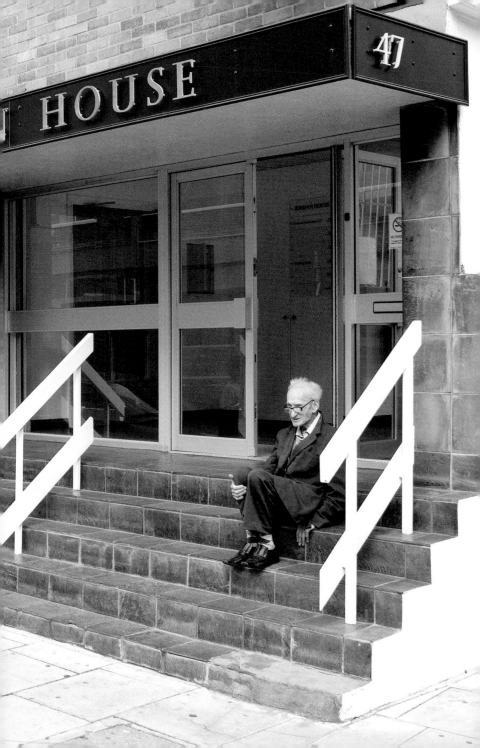

ON GLOBALISATION

In modern times, we all got to keep together. If America was to drop like a stone, then England would drop like a stone. Think about England. England ain't got no coffee in the ground, she ain't got no tobacco growing. If England had everything in the ground would we have visited anywhere else? No. If we had our own tea we woudn't have invaded India. But then again, if we had everything we would probably have invaded ourselves. Oh well. If I went to the jungle and was very clever I would be a missionary and be a person that helps others. But I'm not in a jungle, so I go to the library instead.

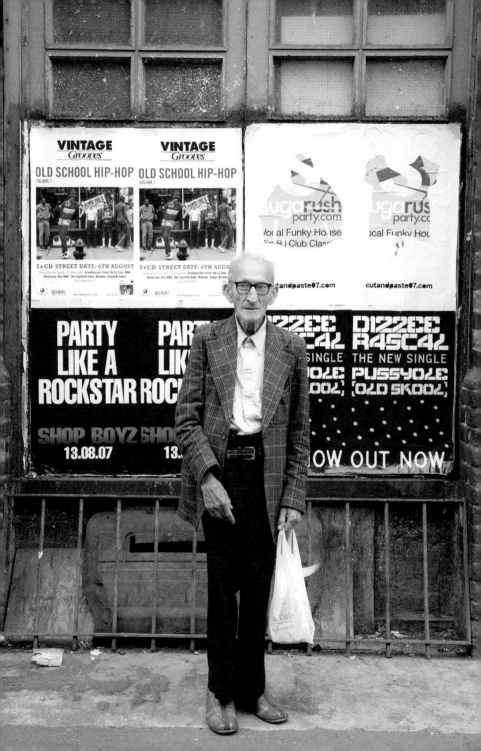

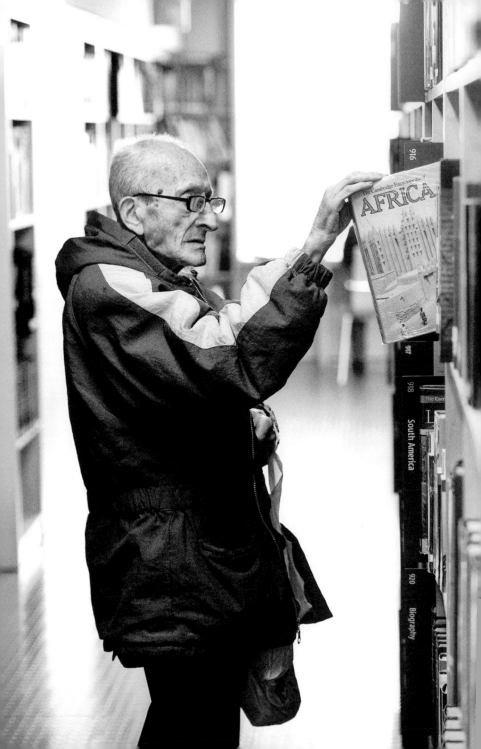

ON READING

I like to go to the library on Monday, Tuesday and ... well, I can't always promise what days I go. I like to read about places in the world. I also read a book called *The Life of Stars*. Do you know Nicolas Cage? He is half German and half Italian. The problem is that nowadays you have to get a girl in to bed to be a star. All the girls are dressed scantily now, ain't it? Audrey Hepburn never dressed scantily. James Cagney never was about sleeping with the girls. What about that Joe Pesci? Where are his parents from? I should look it up.

ON JENNIFER LOPEZ

What about that singer? That Lopez girl. She's Puerto Rican. She can't be English with a name like Lopez. If she was born in Hoxton she would be called Jennifer Smith and that wouldn't be right. I think it's great that people are all mixed up. The most important thing is to be kind to each other.

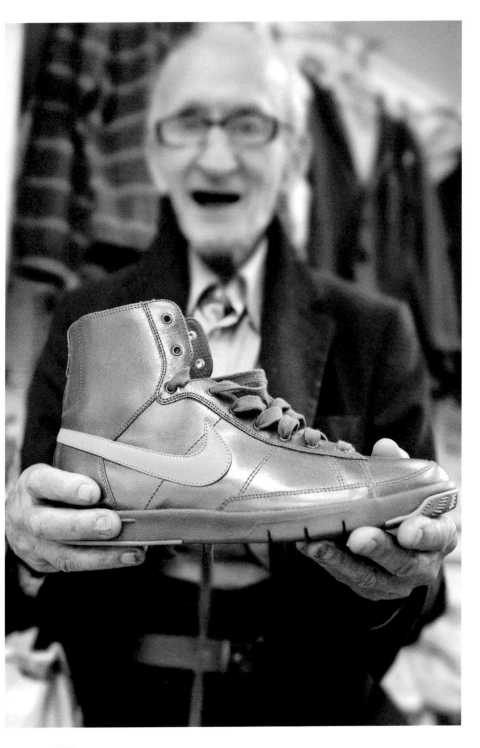

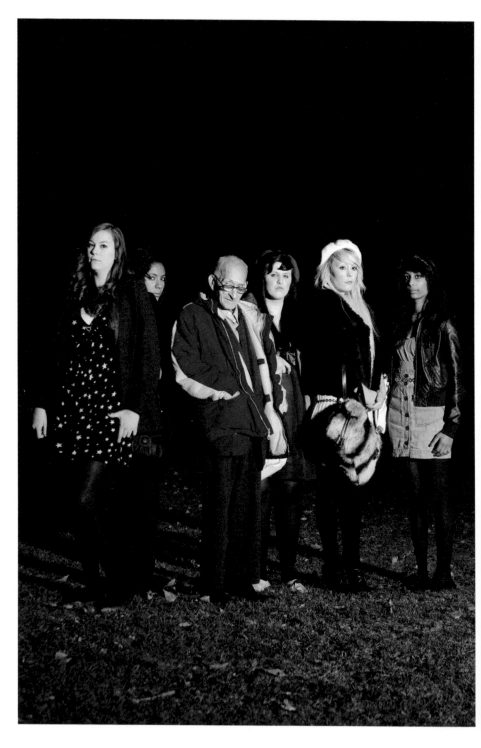

ON STRANGERS

I don't mind people taking pictures of me. But I wouldn't let a girl take a picture of me. She might have a boyfriend. I don't want any trouble. And who knows, he might think she wants to run off with me. You got to be careful where you go nowadays. Martin, if you want to take this picture you had better be quick. I don't take a good photo when my bladder is full.

ON ETHNIC DIVERSITY

Did you know that I stand still when I get trouble with my chest? Well, last Saturday a woman come up to me and said, 'Are you OK?' and I said, 'Why?' She said, 'Because you are standing still', I said 'Oh'. She said she comes from Italy and her husband is Scots-Canadian, and you know what? She wanted to help me! Then I dropped a twenty-pound note on a bus. A foreign man – I think he was Dutch or French said, 'You've dropped a twenty pound note.' English people don't do that because they have betting habits. They take your twenty pound and go put it on the horses. What about Irish girls getting married to Chinamen in Liverpool! Crazy stuff.

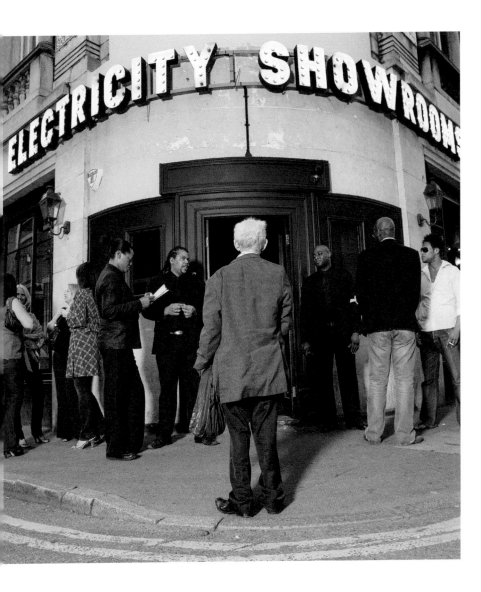

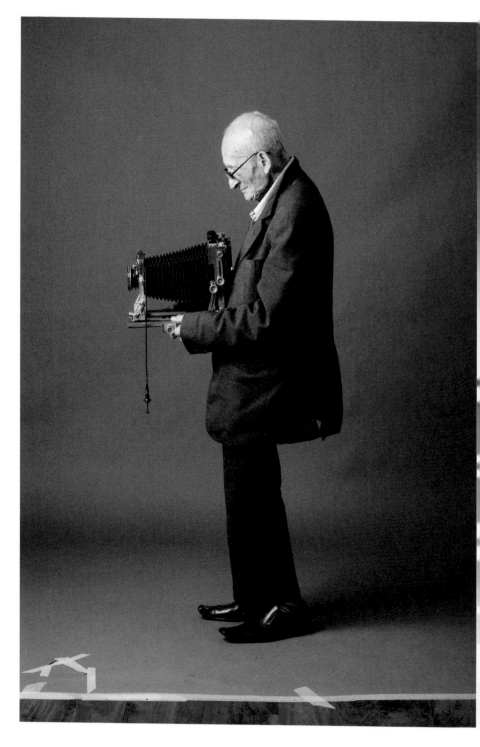

ON RELIGION

I don't believe in God. But there must have been an explosion of some kind. Otherwise how did it all happen? The sky, moon, women, cats... I'm Jewish but I go to the Christian church because the people are nice. We see movies together. Last week we saw *Piranha 3D*. If Jesus had a camera the world would have been different. There might not have been wars because there would be evidence that all his miracles are true. But our brains were too small in those days to invent a camera. Shame

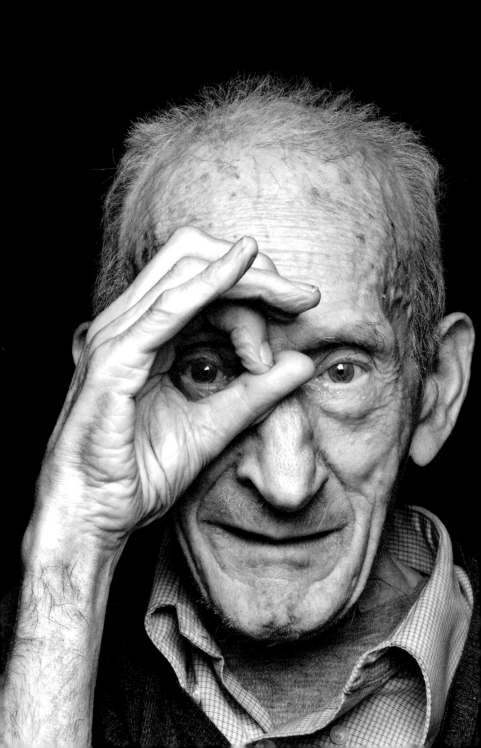

ON THE UNIVERSE

What about those people that study the stars? That's a very good job. I'm interested in the universe. It's more interesting than rivets. If we sent a camera far enough into space we might see people with mouths in their necks and hearts in their heads. But the universe is a mystery, ain't it? How did silver happen, how did copper happen, how did coffee begin? No one knows. The first thing that brought light was candles. Hey, if a meteor landed in Hoxton Square you think anyone could survive? Probably not.

ON ALIENS

They say there is more than one sun, so space must go on forever. There are probably creatures out there. They are probably on their way now. But it could be months and months before they arrive. They could be monsters with three heads. They could be human computers in space that could be watching you right now.

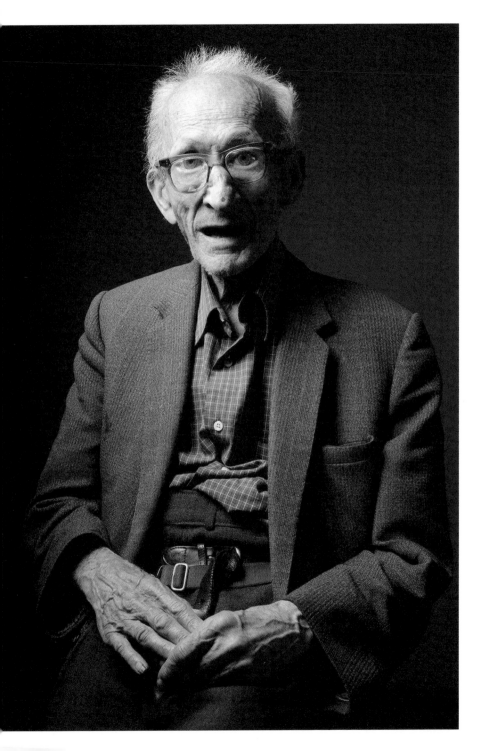

ON HOMOSEXUALITY (AND LETTUCE)

I didn't know what a homosexual was when I was young. Now there are homosexuals in the army. I think it's good – they don't desert on anyone. The only time I would ever be prejudiced is if someone stole my bread away. But I wouldn't do anything about it. That's the government's job to get involved. Do you know that I can't eat lettuce? I've got no teeth, not for ten years. It's hard to like lettuce if you haven't got no teeth.

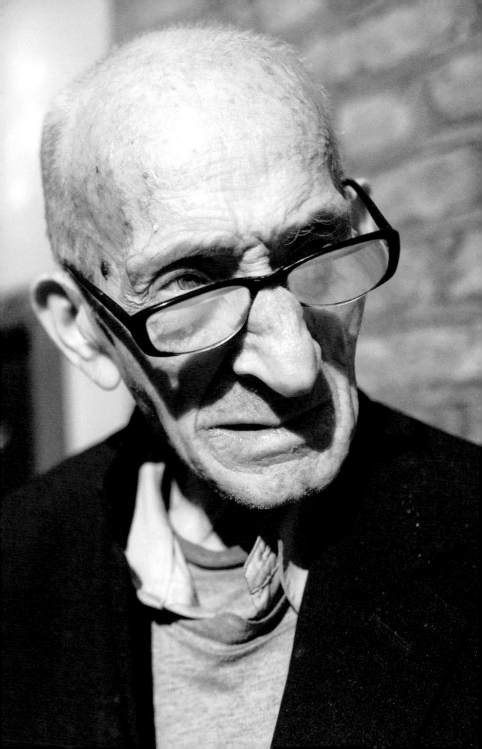

ON DOGS

I met a woman who had a dog. The dog was my friend almost straight away. That's because I didn't move my hands. Dogs know that about me, I never move my hands. Dogs have intuition. They can tell a bad person from a good person.

ON HUMOUR

Lots of things make me laugh. Fruit makes me laugh. To see a dog talking makes me laugh. I like to see monkeys throwing coconuts on men's heads, that's funny. When you see a man going on to a desert island and he is stranded the monkeys are always friendly. You think the monkey is throwing things at your head but really he is throwing the coconuts for you to eat.

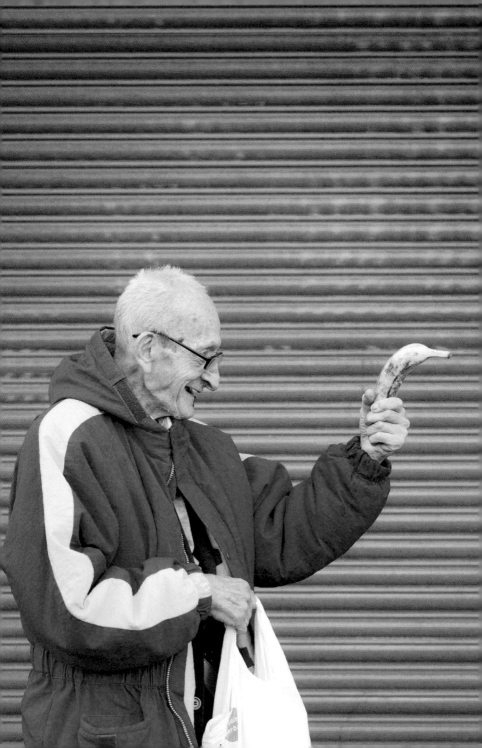

Johnny Depp

ON CINEMA

All the best films were German. There was one
with Peter Lorre and it was called *M*. He went
about murdering children in Düsseldorf and the
blind man finds him because he whistles. Germans
also made sexy films. If you see *Dante's Inferno*
they were all naked in that. I saw *The Sixth Sense*.
That's funny. Everyone was dead! Hey, do you
know something? Hitchcock used to make films
around this part of town.

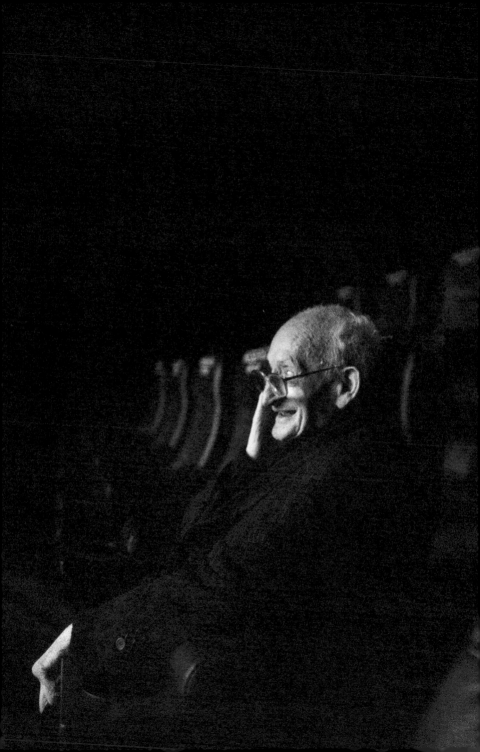

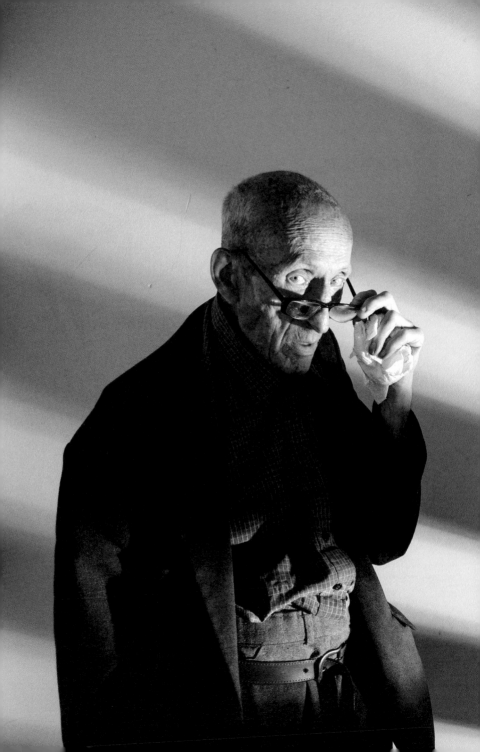

ON SYPHILIS

There was film about a man who found a cure for syphilis. That's a sexual disease for women's vaginas. Just like AIDS but from older times. Dr Ehrlich, he found a magic bullet to cure it. They called the film 'Dr. Ehrlich's Magic Bullet'. It's a pretty good film.

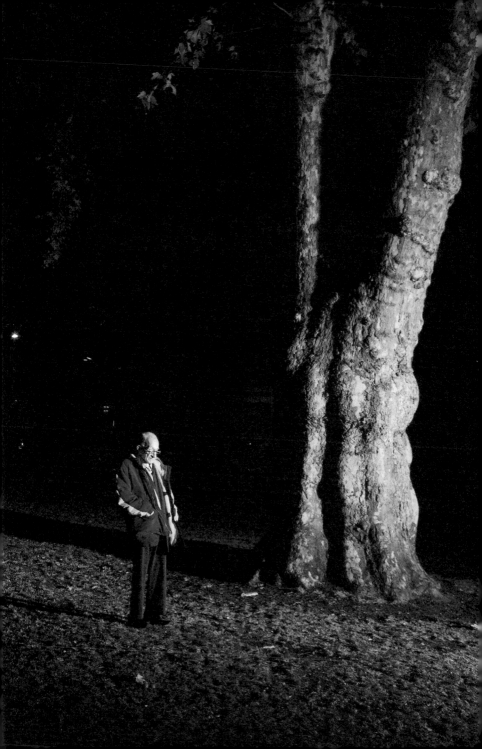

ON REALITY

You know when you see the news and you see a man in front of Big Ben? He's not really there. He's in a studio. It's all like that these days. They put a background to it, like in the war films when you see them running against something. Really it's a screen that's behind them. Nothing is real. Why are people so busy now? With modern technology we shouldn't be so busy. We're always looking at a screen but it's not really there.

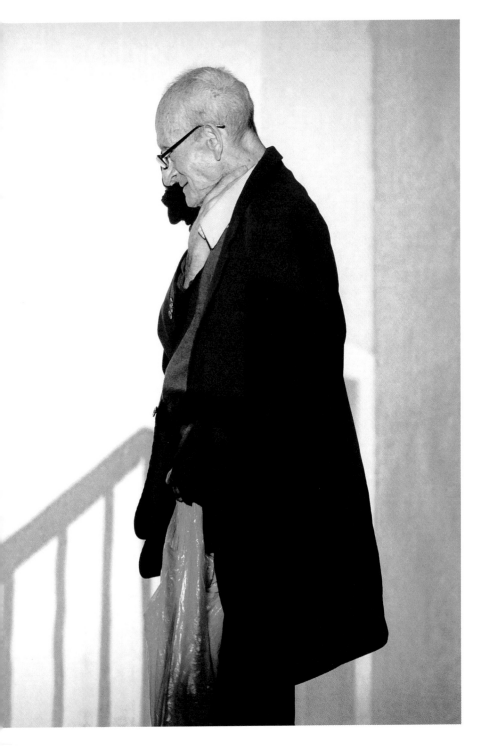

ON TECHNOLOGY

Computers can start wars if you're not careful. You press the wrong button and a bomb goes off. In my time, if a woman wrote on a typewriter and she pressed the wrong key she just took the paper out and put it in the basket. Now you press a button and the whole economy collapses. There is all different computers. There are ones that send satellites up in the air. They are really complicated. But the ones that you get at home – they are just designed to get your bills on. The Microsoft ones, they are harder to use. If they are in the hands of a madman they can be really dangerous.

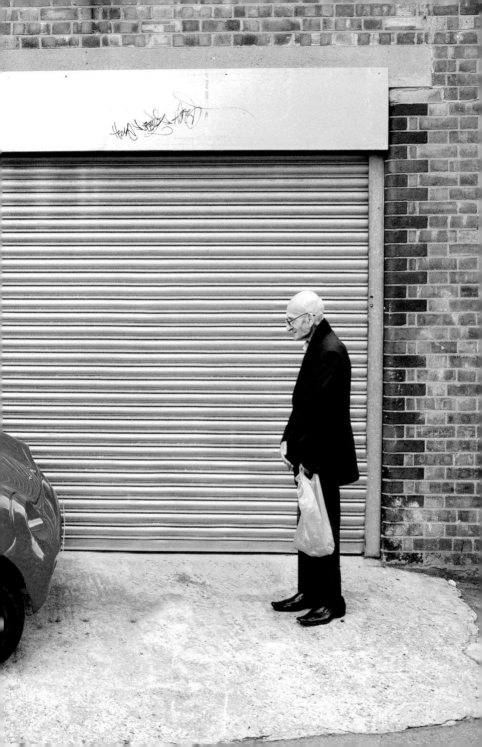

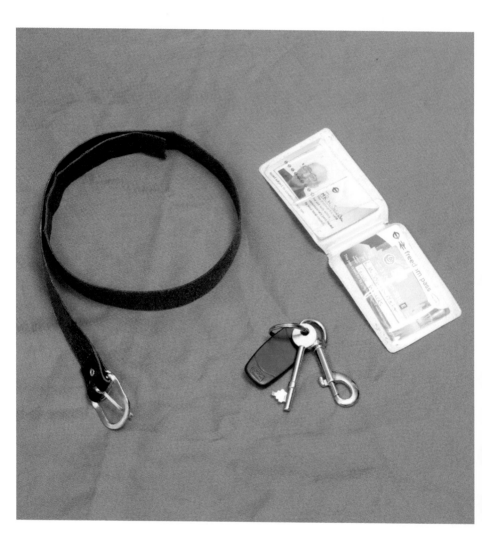

ON THE MOST IMPORTANT
THINGS IN LIFE

The most important thing I own is my keys. And my bus pass. And my belt. If you lose a cigarette or a pound coin you replace it. But if you lose your keys then you're left outside. And you can't get home because you've got no bus pass. And they won't let you on the bus if your trousers have fallen down. This is important stuff, you know.

ON HEALTH

It's very painful getting older. My neck hurts all the time and I can't walk so easy. If I was rich or if I was a queen they would give me all these things to make it go away. They would save me. Nurse! Nurse! Where is everyone here? The corridors are totally empty. And there's no left or right to these hospital beds, only the middle. When I sleep I gotta have all of me covered, just like this. Why do I like to not see anything?

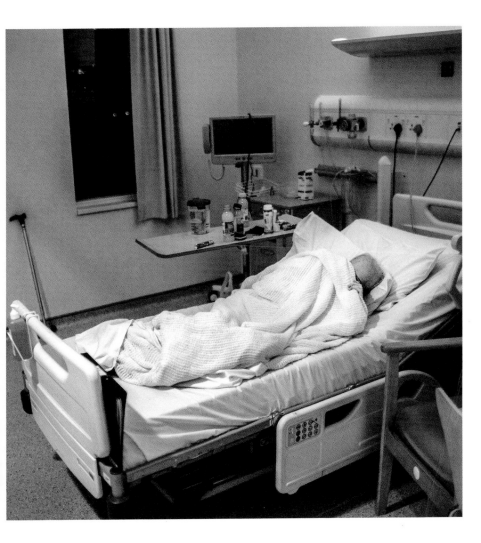

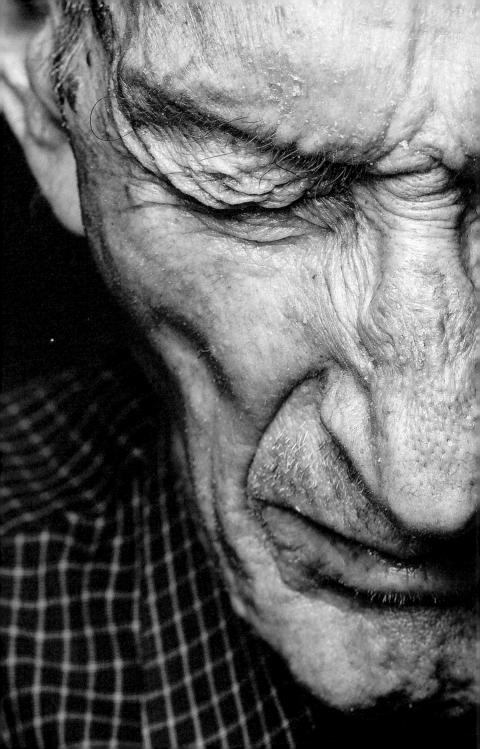

ON THE FUTURE

If I try, I can imagine the future. It's like watching a film. They will make more canals to ease all the roads. But there will still be wars. Pavements will move, nurses will be robots and cars will get smaller and grow wings... you've just got to wait. They will make photographs that talk. You will look at a picture of me and you will hear me say: 'Hello, I'm Joseph Markovitch' and then it will be me telling you about things. Imagine that! I also have an idea that in about fifty years Hoxton Square will have a new market with an amazing plastic rain-cover. So if it rains the potatoes won't get wet. I don't know what else they will sell. Maybe bowler hats. Nothing much changes around here in the end.

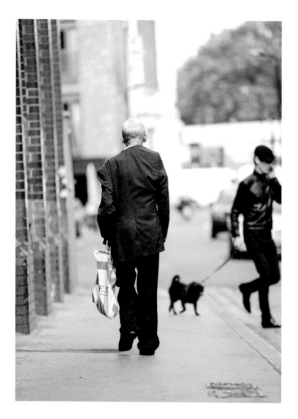

PLEASE READ THIS BIT LAST

Martin Usborne

On December 26th, 2013, Joseph Markovitch passed away, five days short of his 87th birthday.

During his final days in hospital he was visited by both a Pastor and a Rabbi, much to the confusion of the nursing staff. Joseph considered himself Jewish but frequently went to the church because he liked the company and the sandwiches. He told me this once in a whisper and with a finger to his smiling mouth. I wonder what the two religious men must have said on bumping into each other: 'Oh God!' perhaps. Forgive the poor humour but I can hear Joseph laughing as I write this. He had a soft, repetitive laugh which I'll miss: 'He-he-he-he'.

Joseph's life was clearly bound to the neighbourhoods around Shoreditch and Bethnal Green. This is where he was born, where he grew up, where he lived. Over the years the area transformed but his shuffling walk and slightly too-short trousers remained a constant. In his final months, his declining health forced him to move to a care home. Something profound faded in him, just as something faded in the neighbourhood he left behind.

Joseph's last year was painful. I wish I could say otherwise but I can't. First his body failed, then his mind. When at last he couldn't walk any more, he no longer needed his bus pass, nor his keys, nor to do up his own belt. 'These

are the important things in life, you know.' But what else was I expecting to happen? Somewhere in the back of my mind, I imagined the process of growing old as a gentle retreat into darkness rather like a spent actor leaving the stage backwards, stumbling at the last. But life is never as we imagine. Live it while you can. This was Joseph's parting lesson for me.

On an unusually sunny winter's day, shortly after Joseph passed away, his simple coffin was lowered into the ground at a Jewish cemetery just east of London. A few family members attended along with a small number of friends from his Saturday church group. In the Jewish tradition the tombstone is not set into the ground until some months after the burial. The earth is left turned, raw and unfinished. I soon realised why. On the day of the burial I wasn't sure how to react. My feelings were also unfinished. There was no rain and I felt no tears. Six months later, on a more overcast day, I returned to see the stone being set in firmer ground and I was able to say goodbye.

After the funeral I met Joseph's nephew, a man called Anthony, who later sent me a photo of Joseph aged 16 (overleaf). I love this picture – I see his whole life in those eyes, perhaps because his expression seems almost identical to how it appeared to me some 70 years later.

Joseph was an unusual friend. In some ways I knew him intimately, in other ways not at all. He spoke with candour but his tales and ideas seemed to come from a distant galaxy. And yet, across that vast divide of age and

culture, there was something immediate to understand: he was a kind man. He would frequently stop strangers in the street and ask where they were from. This occasionally made the politically correct Londoner in me nervous, but his gentle manner and total innocence would win over the most wary of people. And it was this openness, unburdened by self-consciousness, which made him so special to me.

Joseph had a quiet life. But it was a rich life. He didn't travel the world, but he travelled a long way in his mind. He lived his final years alone, but he was deeply interested in others. He was vulnerable. But he was very much alive. Of the many things I learned from him, I think one stands above all else: see other people as they are. To meet a stranger directly and with clear eyes, as he did on a daily basis on his many rambling walks across East London, requires a level of openness that few of us have, but all of us should strive for.

Thank you for opening my eyes, Joe.

I hope I saw you as you were.

Martin Usborne,
Hackney, East London.

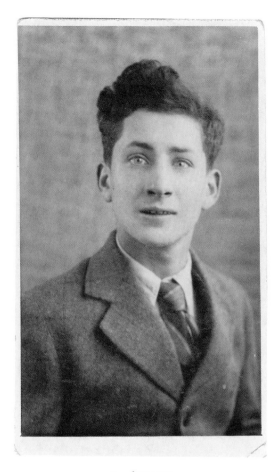

Aged 16, 1943

JOSEPH MARKOVITCH

01.01.1927 - 26.12.2013